VOICES

Canadian representatives: General Publishing
Co., Ltd., 30 Lesmill Road, Don Mills,
Ontario M3B 2T6.
International representatives: Worldwide Media
Services, Inc., 30 Montgomery Street, Jersey City,
New Jersey 07302.

ISBN 1-56138-316-3

Cover illustration: *The Beaze Find* by
 Phyllis Berman, courtesy Marian Locks Gallery
Cover design by Toby Schmidt
Interior design by Nancy Loggins
Interior illustrations by Kathy Borosky
Edited by Melissa Stein

Typography: ITC Berkeley by Deborah Lugar
Printed in Hong Kong

This book may be ordered from the publisher.
Please add $2.50 for postage and handling.
But try your bookstore first!

Running Press Book Publishers
125 South Twenty-second Street
Philadelphia, Pennsylvania 19103-4399

VOICES

*A woman's
journal of
self-expression,
with quotes and
space for notes*

RUNNING PRESS
Philadelphia, Pennsylvania

We are the invisible majority, and
we need to make ourselves visible.

<small>MICHELLE HARRISON</small>
20th-century American psychiatrist

Women come to writing, I believe,
simultaneously with self-creation.

CAROLYN HEILBRUN, B. 1926
American writer

You can communicate things that you feel and see. You are a voice You don't have to ask anyone's permission.

FAITH RINGGOLD, B. 1930
African-American artist

Nobody can dub you with dignity.
That's yours to claim.

ODETTA, B. 1930
African-American folk singer

. . . the personal life deeply lived
always expands into truths
beyond itself.

ANAÏS NIN (1903–1977)
French-born American writer

...the common bonds we share as
women – a need for respect, recognition
and reward – are the links in the chain
that will pull us all forward.

WENDY REID CRISP, B. 1944
American businesswoman

*Women have burnt like beacons in all
the works of all the poets from the
beginning of time.*

VIRGINIA WOOLF (1882–1941)
English writer

. . . while we honor our unearthed
"herstory," we sometimes forget that
every day we're also making it

ROBIN MORGAN, B. 1941
American writer and poet

There exists a true humanity, which will ever remain a gift. . . . Strange and wonderful is it to consider how . . . we are bound to foreigners whom we have never seen and to dead men and women whose names we have never heard and shall never hear, more closely even than if we were all holding hands.

ISAK DINESEN [KAREN BLIXEN] (1885–1962)
Danish writer

We women are the meeting place of the highest and lowest, and of minutia and riches; it is for us to see, and understand, and have pride in representing ourselves truly. Perhaps we must say to man . . . "The time may have come for us to forge our own identity, dangerous as that will be."

FLORIDA SCOTT-MAXWELL (1883–1978)
English psychologist

Women must try to do things as men have tried. When they fail, their failure must be but a challenge to others.

AMELIA EARHART (1897–1937)
American aviator

We are not judged by what we are
basically. We are judged by how hard
we use what we have been given.

FLANNERY O'CONNOR (1925–1964)
American writer

A woman is like a tea bag. You never know how strong she is until she gets into hot water.

ELEANOR ROOSEVELT (1884–1962)
American stateswoman and humanitarian

I know I have the body of a weak and feeble woman; but I have the heart and stomach of a King, and of a King of England, too.

ELIZABETH I (1533–1603)
Queen of England

The true Republic: men, their rights
and nothing more; women, their rights
and nothing less.

SUSAN B. ANTHONY (1820–1906)
American women's suffrage leader

Any truth creates a scandal.

MARGUERITE YOURCENAR (1904–1988)
French writer

The truth I do not dare to know I
muffle with jest.

EMILY DICKINSON (1830–1886)
American poet

*When women's laughter is directed
toward authority, it can bring down
the house.*

REGINA BARRECA
20th-century American scholar

I'd like to see a woman elected President. Women have been running men for centuries—it would be easy for them to run a country.

MAE WEST (1892–1980)
American actress

If the world were a logical place,
men would ride side-saddle.

<small>RITA MAE BROWN, B. 1944</small>
American writer and poet

Beware of the man who praises
liberated women; he is planning to
quit his job.

Erica Jong, b. 1942
American writer

What woman needs is not as a woman
to act or rule, but as a nature to grow,
as an intellect to discern, as a soul to
live freely and unimpeded, to unfold
such powers as were given her when
we left our common home.

MARGARET FULLER (1810–1850)
American journalist

Nurturing one another is what it's all
about, and this generation has a long
way to go before we love too much.

MARIANNE WILLIAMSON, B. 1953
American writer and spiritualist

The one thing that doesn't abide by
majority rule is a person's conscience.

HARPER LEE, B. 1926
American writer

A thinking woman sleeps with monsters.

ADRIENNE RICH, B. 1929
American poet

We all struggle with the mythologies of our time If we can understand these mythologies, we can see that they are not absolutes but someone else's invention. Then we can start to reverse the process and say, I will invent my mythologies.

SHIRLEY ABBOTT, B. 1934
American writer

Symbols give us our identity, our self image, our way of explaining ourselves to ourselves and to others. Symbols in turn determine the kinds of stories we tell; and the stories we tell determine the kind of history we make and remake.

MARY ROBINSON, B. 1944
Irish President

*. . . freedom and independence can't be
wrested from others – from the society
at large, or from men – but can only be
developed painstakingly, from within.*

COLETTE DOWLING
20th-century American writer

Freeing yourself was one thing;
claiming ownership of that freed self
was another.

TONI MORRISON, B. 1931
African-American writer

Certain springs are tapped only when
we are alone women need solitude
in order to find again the true essence
of themselves; that firm strand which
will be the indispensable center of a
whole web of human relationships.

ANNE MORROW LINDBERGH, B. 1906
American writer

*Freedom—however you want it—comes
from new ways of living together.*

CHARLOTTE BONNY COHEN
20th-century American writer

Freedom is a daily necessity like water,
and we love most loyally and longest
those who allow us at least occa-
sionally to vanish and wander the
curious night.

MARGE PIERCY, B. 1934
American writer and poet

A real friendship is a light thing. A real friend holds you loosely.

ANNE RIVERS SIDDONS, B. 1936
American writer

True things meet if you respect the
integrity of your human fellow friend,
a bridge of understanding will be there
between you, and being together will
be an embrace

LIV ULLMAN, B. 1939
Norwegian actress and writer

Humans,
Not places,
Make memories.

AMA ATA AIDOO, B. 1942
African writer

Anyone can be a good listener
It's hard to be a wise listener.

MAEVE BINCHY, B. 1940
Irish writer

*The biggest mistake is believing there is
one right way to listen, to talk, to have
a conversation – or a relationship.*

DEBORAH TANNEN, B. 1945
American linguist and writer

People love the way they're capable of loving—but that's not always how you want them to love or how you think they should love.

<small>PATTI DAVIS, B. 1952</small>
American actress

Love happens. It is a miracle that happens by grace. We have no control over it. It happens. It comes, it lights our lives, and very often it departs. We can never make it happen nor make it stay.

IRENE CLAREMONT DE CASTILLEJO (1896–1973)
English psychoanalyst

Did all lovers feel helpless and valiant
in the presence of the beloved? Helpless
because the need to roll over like a pet
dog is never far away. Valiant because
you know you would slay a dragon
with a pocketknife if you had to.

JEANETTE WINTERSON, B. 1959
English writer

Pity me that the heart is slow to learn
What the swift mind beholds at
every turn.

EDNA ST. VINCENT MILLAY (1892–1952)
American poet

She breathed in and out, her body
a mere shelter for the mating of
unfathomable will to unfathomable
possibility.

GLORIA NAYLOR, B. 1950
American writer

. . . we need to speak our body's experiences . . .

XAVIÈRE GAUTHIER
20th-century French writer

*Why indeed should one distinguish
between body, and emotion, and
intellect?*

Britt Arenander, b. 1941
Swedish journalist

The real world is often stranger than fiction, so strange that it leaves us shocked and astounded. It possesses a more vital worth, a more wondrous ability to delight.

YANG JIANG
20th-century Chinese-American writer

Our life is a faint tracing on the surface of mystery, like the idle, curved tunnels of leaf miners on the face of a leaf.

ANNIE DILLARD, B. 1945
American writer

The mind loves to not know completely.
Situations that are not familiar tune
the system. To get smarter, do the
unfamiliar.

MAGALY RODRIGUEZ MOSSMAN
20th-century American writer

Creativity can be described as letting go of certainties.

GAIL SHEEHY, B. 1937
American journalist and writer

A fixed idea isn't always a good idea.

COLETTE (1873–1954)
French writer

Revolutions produce other men, not new ones.

<small>BARBARA TUCHMAN (1912–1989)</small>
American historian

Life is a movable feast . . . a tour in a
post chaise, but who's to be considered
as moving, it or you? The answer is —
quick over the abyss, and be damned to
being. Start doing.

HORTENSE CALISHER, B. 1911
American writer and educator

They sicken of the calm, who know the storm.

DOROTHY PARKER (1893–1967)
American writer

Every door marked "no" by
conventional standards seemed to hold
the key to some lascivious pleasure I
just had to have.

MARIANNE WILLIAMSON, B. 1953
American writer and spiritualist

We see achievement as purposeful and monolithic, like the sculpting of a massive tree trunk that has first to be brought from the forest and then shaped by long labor to assert the artist's vision, rather than something crafted from odds and ends, like a patchwork quilt, and lovingly used to warm different nights and bodies.

MARY CATHERINE BATESON, B. 1939
American anthropologist

Work is love made visible.

AMA ATA AIDOO, B. 1942
African writer

*It is good to have an end to journey
towards; but it is the journey that
matters, in the end.*

Ursula K. Le Guin, b. 1929
American writer

The true self is always in motion like
music, a river of life, changing, moving,
failing, suffering, learning, shining.
That is why you must freely and
recklessly make new mistakes.

BRENDA UELAND (1891–1985)
American writer and editor

Everything is chance, or nothing is chance. If I believed the first, I would be unable to live on, but I am not yet fully convinced of the second.

ETTY HILLESUM (1914–1943)
Dutch diarist

The world is full of currents we can't
lay corporeal hands on—trust, faith,
gravity, magnetic fields, love
They add richness to all our hours.

ERMA J. FISK
20th-century American writer

Sometimes you have to trade one philosophy for another. You try them on like shoes and find one that fits you at that particular moment.

EVELYN WILDE MAYERSON, B. 1935
American writer

*Remember, you do not need to tell
anyone what your contributions mean
and it is more than likely they will
hold meaning for you alone anyway.
Do not explain. This is your right.*

WHITNEY OTTO
20th-century American writer

Self-confidence: When you think that
your greatest fault is being too hard
on yourself.

JUDITH VIORST, B. 1931
American writer

. . .self-doubt. . .*a ball and chain*
in the place where your mind's wings
should have grown.

AYN RAND (1905–1982)
Russian-born American writer and critic

If you dream it, have faith in it and struggle for it.

MARIAN WRIGHT EDELMAN, B. 1939
African-American writer

. . .the great dreams never really die.
They always leave their seeds behind.

JOAN BAUER
20th-century American writer

A thing cannot be more than impossible.

Rosie Thomas
20th-century English writer

If we had no winter, the spring would not be so pleasant; if we did not sometimes taste of adversity, prosperity would not be so welcome.

ANNE BRADSTREET (1612–1672)
English-American writer

The art of life is not controlling what happens to us, but using what happens to us.

Gloria Steinem, b. 1934
American writer

. . . she conceived life as a road down which one traveled; an easy enough road through a broad country, and that one's destination was there from the very beginning, a measured distance away, standing in the ordinary light like some plain house where one went in and was greeted by respectable people and was shown to a room where everything one had ever lost or put aside was gathered together, waiting.

MARILYNNE ROBINSON, B. 1944
American writer

I must let myself breathe. . . . A day
doesn't have to exhaust me to seem
worthy of having been lived.

JOYCE CAROL OATES, B. 1938
American writer

"How does one grow up?" I asked a friend. She answered, "By thinking."

MAY SARTON, B. 1912
Belgian-American writer

For every situation there is a proper
distance. Growing up is just a matter of
gaining perspective. Sometimes you just
need to jump up for a moment, a foot
above the earth.

REBECCA LEE, B. 1894
American writer

What we lack in distance we make up
for in height, and once in a while we
stand tall enough to touch the sky, look
the sun straight in the eye and laugh.

LINDA ELLERBEE, B. 1944
American journalist

I desire no future that will break the ties of the past.

GEORGE ELIOT [MARY ANN EVANS] (1819–1880)
English writer

We all learn from the past, we just
shouldn't live there.

SHIRLEY TEMPLE BLACK, B. 1928
American actress and diplomat

Passed years seem safe ones,
vanquished ones, while the future lives
in a cloud, formidable from a distance.
The cloud clears as you enter it.
I have learned this.

BERYL MARKHAM (1902–1986)
American aviator

It is our inward journey that leads us
through time — forward or back, seldom
in a straight line, most often spiraling.
Each of us is moving, changing, with
respect to others. As we discover, we
remember; remembering, we discover;
and most intensely do we experience
this when our separate journeys
converge.

EUDORA WELTY, B. 1909
American writer

People alter so much that there is something new to be observed in them forever.

JANE AUSTEN (1775–1817)
English writer

Memory is an abstract painting—it does not present things as they are, but rather as they feel.

EUGENIA COLLIER, B. 1928
African-American writer

The patchwork seemed a metaphor for memory—bits and pieces from the past useful in the present—and for the deeply loving and caring way in which women transform the world around them, starting from what they have as individuals and weaving it into a pattern of life.

GLORIA VANDERBILT, B. 1924
American designer

At some point in life the world's beauty
becomes enough. You don't need to
photograph, paint or even remember it.
It is enough. No record of it needs to be
kept and you don't need someone to
share it with or tell it to. When that
happens—that letting go—you let go
because you can So you can sleep
and there is reason to wake.

TONI MORRISON, B. 1931
African-American writer

Are we going to throw away our
paradise, or are we going to keep it?

CAROLYN SEE, B. 1934
American writer

Woman wants to destroy aloneness,
recover the original paradise.

ANAÏS NIN (1903–1977)
French-born American writer

The entire being of a woman is a secret which should be kept.

Isak Dinesen [Karen Blixen] (1885–1962)
Danish writer

We have no place else to begin
But with our hungers and our
caring . . .

MARGE PIERCY, B. 1934
American writer and poet

When kindness has left people, even for
a few moments, we become afraid of
them as if their reason has left them.

WILLA CATHER (1873–1947)
American writer and poet

You cannot shake hands with a clenched fist.

INDIRA GANDHI (1917–1984)
Indian Prime Minister

It is not power that corrupts but fear.

AUNG SAN SUU KYI, B. 1945
Burmese human-rights activist

It would be easier to live with a greater
clarity of ambition, to follow goals that
beckon toward a single upward pro-
gression. But perhaps what women
have to offer in the world today . . . lies
in the very rejection of forced choices:
work or home, strength or vulnera-
bility, caring or competition, trust or
questioning. Truth may not be so
simple.

MARY CATHERINE BATESON, B. 1939
American anthropologist

*. . . only one thing is more frightening
than speaking your truth. And that is
not speaking.*

Naomi Wolf, b. 1963
American writer

. . . the other side of every fear is a freedom. . . . we must take charge of the journey, urging ourselves past our own reluctance and misgivings and confusion to new freedom.

MARILYN FERGUSON, B. 1938
American writer

The joy of a time is a leap forward of a
man or a people.
The moment of the leap is ready today.

MURIEL RUKEYSER (1913–1980)
American poet